1 MONTH OF
FREE
READING

at

www.ForgottenBooks.com

By purchasing this book you are eligible for one month membership to ForgottenBooks.com, giving you unlimited access to our entire collection of over 1,000,000 titles via our web site and mobile apps.

To claim your free month visit:

www.forgottenbooks.com/free1110255

ISBN 978-0-331-81219-0
PIBN 11110255

This book is a reproduction of an important historical work. Forgotten Books uses state-of-the-art technology to digitally reconstruct the work, preserving the original format whilst repairing imperfections present in the aged copy. In rare cases, an imperfection in the original, such as a blemish or missing page, may be replicated in our edition. We do, however, repair the vast majority of imperfections successfully; any imperfections that remain are intentionally left to preserve the state of such historical works.

CATALOGUE

OF

Ancient & Modern Pictures

THE COLLECTION OF

CLAUDE A. C. PONSONBY, ESQ.

ALSO

IMPORTANT

Pictures by Old Masters

AND

Works of the Early English School

THE PROPERTY OF

WALTER PLEYDELL BOUVERIE, ESQ.
Deceased; late of Lavington Manor, Wilts.

BROWNLOW POULTER, ESQ.
Deceased; late of 15 Western Parade, Southsea

A. HICHENS, ESQ.
Deceased; late of 27 Chester Street, S.W., and Monkshatch, Guildford

AND OTHERS

WHICH

Will be Sold by Auction by

MESSRS. CHRISTIE, MANSON & WOODS

AT THEIR GREAT ROOMS

8 KING STREET, ST. JAMES'S SQUARE

On SATURDAY, MARCH 28, 1908

AT ONE O'CLOCK PRECISELY

May be viewed Three Days preceding, and Catalogues had, at Messrs. CHRISTIE, MANSON AND WOODS' Offices, 8 *King Street, St. James's Square, S.W.*

CONDITIONS OF SALE.

I. THE highest Bidder to be the Buyer; and if any dispute arise between two or more Bidders, the Lot so in dispute shall be immediately put up again and re-sold.

II. No person to advance less than 1*s.*; above Five Pounds, 5*s.*; and so on in proportion.

III. In the case of Lots upon which there is a reserve, the Auctioneer shall have the right to bid on behalf of the Seller.

IV. The Purchasers to give in their Names and Places of Abode, and to pay down 5*s.* in the Pound, or more, in part of payment, or the whole of the Purchase-Money *if required*; in default of which, the Lot or Lots so purchased to be immediately put up again and re-sold.

V. The Lots to be taken away and paid for, whether genuine and authentic or not, with all faults and errors of description, at the Buyer's expense and risk, within TWO DAYS from the Sale; Messrs. CHRISTIE, MANSON AND WOODS not being responsible for the correct description, genuineness, or authenticity of, or any fault or defect in, any Lot, and making no warranty whatever.

VI. To prevent inaccuracy in delivery, and inconvenience in the settlement of the Purchases, no Lot can on any account be removed during the time of Sale; and the remainder of the Purchase-Money must absolutely be paid on the delivery.

VII. Upon failure of complying with the above Conditions, the Money deposited in part of payment shall be forfeited; all Lots un-cleared within the time aforesaid shall be re-sold by public or private Sale, and the deficiency (if any) attending such re-sale shall be made good by the defaulter at this Sale.

CATALOGUE.

On SATURDAY, MARCH 28, 1908,

AT ONE O'CLOCK PRECISELY.

The Collection of
CLAUDE A. C. PONSONBY, *Esq.*

DRAWINGS.

F. BARTOLOZZI, R.A.

1 PORTRAIT OF HENRIETTA, LADY DUNCANNON, seated—*chalk*
13 *in.* by 9¾ *in.*
Engraved

26. 5.

F. BARTOLOZZI, R.A.

2 PORTRAIT OF GEORGIANA, DUCHESS OF DEVONSHIRE, with a harp—*chalk*
10¼ *in.* by 7½ *in.*

31. 10.

J. B. CIPRIANI, R.A.

3 HOPE AND FORTUNE
11 *in.* by 11 *in.*
Engraved by I. Minasi

9. 9.

GAINSBOROUGH.

4 PORTRAIT OF ANTHONY, FIFTH EARL OF SHAFTESBURY, in
white and blue dress, seated—*pastel*
Oval—20 in. by 16 *in.*

52. 10.

O. HUMPHREY, R.A.

5 PORTRAIT OF LADY BARBARA ASHLEY, when a child, in white
dress, seated in a landscape—*pastel*
40½ *in.* by 30½ *in.*

2 10.

O. HUMPHREY, R.A.

6 PORTRAIT OF GEORGIANA, DUCHESS OF DEVONSHIRE—*chalk*
7½ *in.* by 6¼ *in.*

52. 10.

J. E. LIOTARD.

7 PORTRAIT OF THE ARTIST, in blue coat and red cap—*pastel*
24½ *in.* by 19½ *in.*

126.

J. E. LIOTARD.

8 PORTRAIT OF THE HON. GEORGE PONSONBY, in green coat
powdered wig—*pastel*
24½ *in.* by 19½ *in.*

29. 8.

J. E. LIOTARD.

9 PORTRAIT OF WILLIAM BRABAZON, FIRST BARON PONSONBY,
in brown coat, powdered hair—*pastel*
24½ *in.* by 19½ *in.*

44. 2

J. E. LIOTARD.

10 PORTRAIT OF LADY GEORGIANA SPENCER, in white dress—
pastel
Oval—22½ in. by 17½ *in.*

5. 5

PICTURES.

ENGLISH SCHOOL.

MARY BEALE.

11 PORTRAIT OF ARABELLA, daughter of Sir Winston Churchill, in grey dress. In an oval
29½ *in.* by 24½ *in.*

39 . 18.

J. S. COPLEY, R.A.

12 PORTRAIT OF WILLIAM, SECOND EARL OF BESSBOROUGH, seated at a table
22½ *in.* by 18½ *in.*

94 . 10

GAINSBOROUGH.

13 PORTRAIT OF MARGARET GEORGIANA, COUNTESS SPENCER, in brown dress. In an oval
29 *in.* by 24 *in.*

73 . 10

T. HICKEY.

14 PORTRAIT OF JOHN WEBB, ESQ., in blue coat, holding his cane
Signed, and dated 1784
Oval—10½ *in.* by 9 *in.*

56 . 14

J. HOPPNER, R.A.

15 PORTRAIT OF LADY CAROLINE PONSONBY, in white dress with blue sash
29½ *in.* by 22½ *in.*

220 . 10

H. HOWARD, R.A.

16 PORTRAIT OF LAVINIA, COUNTESS SPENCER, in dark dress and
white cap. In an oval
23½ *in.* by 19½ *in.*

68. 5.

A. KAUFFMAN, R.A.

17 PORTRAIT OF GEORGIANA, DUCHESS OF DEVONSHIRE, in white
cloak, trimmed with blue
28½ *in.* by 24½ *in.*

73. 10.

A. KAUFFMAN, R.A.

18 PORTRAIT OF HENRIETTA SPENCER, afterwards Countess of
Bessborough
28½ *in.* by 24 *in.*

105.

KNELLER.

19 PORTRAIT OF POPE, in brown dress, holding a scroll
28½ *in.* by 23½ *in.*

7. 7.

SIR E. LANDSEER, R.A.

20 THE RETURN FROM THE WARREN
Portrait of the Hon. A. Ponsonby, with the pony and
large dog belonging to him, and the small dog belonging
to the artist
82 *in.* by 65 *in.*
Exhibited at the Royal Academy, 1843
Exhibited at Burlington House, 1874
Engraved by T. Landseer, A.R.A.

346. 10.

SIR E. LANDSEER, R.A.

21 A WHITE MARE AND A FOAL, in a landscape
Portrait of an Arab mare given by Princess Charlotte
to Lady Barbara Ponsonby, afterwards Lady De Mauley
27½ *in.* by 35½ *in.*
Exhibited at Burlington House, 1874

105.

SIR T. LAWRENCE, P.R.A.

22 Portrait of Lady Caroline Lamb

3 25 . 10 21 *in.* by 18½ *in.*

SIR T. LAWRENCE, P.R.A. (After).

23 Portrait of William Lamb, second Viscount Melbourne, by

16. 16—— Emily Sturt, 1830

30 *in.* by 25 *in.*

SIR P. LELY.

24 Portrait of James, Duke of York, in armour, with ribbon

23. 2——— of the Garter and lace cravat

29½ *in.* by 24 *in.*

SIR P. LELY.

25 Portrait of Sir Winston Churchill, in brown slashed

42——— dress, with flowing hair

23 *in.* by 23½ *in.*

SIR P. LELY.

26 Portraits of Winston ·and Arabella, children of Sir

14 7.——— Winston Churchill

31½ *in.* by 36 *in.*

G. MORLAND.

27 A Landscape, with gipsies and donkey

11. 11.——— *On panel—*7 *in.* by 10½ *in.*

G. MORLAND.

28 Gathering Clouds

10. 10 .——— 24½ *in.* by 29½ *in.*

NASYMTH.

29 A LANDSCAPE, with a church and gipsies
On panel—6½ in. by 9½ in.

6 . 6 .

SIR J . REYNOLDS, P.R.A.

30 PORTRAIT OF HENRIETTA SPENCER, LADY DUNCANNON, in
dark cloak and white fichu
29 in. by 22½ in.

54. 12.

SIR J. REYNOLDS, P.R.A.

31 PORTRAIT OF GEORGIANA, DUCHESS OF DEVONSHIRE
23 in. by 19½ in.

162. 15.

SIR J. REYNOLDS, P.R.A.

32 PORTRAIT OF GEORGIANA, DUCHESS OF DEVONSHIRE, AND
HER DAUGHTER
13 in. by 10¾ in.

86. 2.

SIR J. REYNOLDS, P.R.A.

33 CUPID AS A LINK-BOY
13 in. by 11 in.

6 . 6 .

ROMNEY.

34 PORTRAIT OF SIR JOHN WEBB, in red coat with white stock;
powdered hair
Oval—27½ in. by 24 in.

14. 1 4.

DUTCH AND FLEMISH SCHOOLS.

H. VAN AVERCAMP.

35 A River Scene, with fishermen drawing a net

12. 12. —On panel—10 in. by 19½ in..

H. DE BLES.

36 Saint Catherine

Small three-quarter figure of the Saint, in a richly
embroidered robe and head-dress, with one of her emblems,
a sword, in front of her; landscape background

735.

On panel—33½ in. by 11¼
Exhibited at Burlington House, 1907

H. DE BLES.

37 Saint Barbara

Small three-quarter figure of the Saint in blue and red
drapery, holding two of her emblems; a ring in her left
hand, and a peacock feather in her right; landscape
background

On panel—33½ in. by 11¼ in.
Exhibited at Burlington House, 1907

A. BRAUWER.

38 Two Peasants Smoking and Drinking

13. 13.—— On panel—9½ in. by 8½ in.

J. BRUEGHEL.

39 A Woody River Scene, with a village, figures and animals

7. 7.—— On copper—14½ in. by 20½ in.

B (28)

P. BRUEGHEL.

6. *6.*

40 THE MINSTREL
—— *On panel—29 in. by 41 in.*

A. ELSHEIMER.

10. 10

41 A LANDSCAPE, with the Madonna and Child, and Saint John
On copper—8 in. by 10½ in.

B. VAN DER GUCHT.

68. 5

42 PORTRAIT OF FREDERICK, THIRD EARL OF BESSBOROUGH, on
—horseback
Signed, and dated 1776
35½ in. by 30 in.

J. VAN KESSEL.

12. 12

43 FLOWERS IN A VASE
Signed, and dated 1652
On panel—15½ in. by 11½ in.

'J. DE MABUSE.

44. 2.

44 THE VIRGIN AND CHILD
Three-quarter figure of the Virgin, less than life-size,
seated, her left arm resting on a pedestal, and holding the
Child, who stands on her lap, with her right; He holds a
bunch of cherries in either hand ; architectural and curtain
background on the left, and on the right a landscape, with
a castle in the foreground
On panel—26½ in. by 19¾ in.
Exhibited at Burlington House, 1907

M. J. MIEREVELT.

8. 8.

45 PORTRAIT OF A GENTLEMAN, in dark dress with lace collar.
In an oval
28½ in. by 20½ in.

G. NETSCHER.

46 PORTRAITS OF A GENTLEMAN AND A LADY, in black dresses
with white lace collars—*a pair* 2
On panel—11 *in.* by 8½ *in.*

94 . 10.

POURBUS.

47 PORTRAIT OF AN ARTIST, in black dress with white ruff, hold-
ing a palette
On panel—24½ *in.* by 18½ *in.*

8 . 8

POURBUS.

48 PORTRAIT OF A GENTLEMAN, in red robe and brown cap
On panel—24½ *in.* by 18½ *in.*

9 . 9

REMBRANDT.

49 HEAD OF A BOY, with brown coat and hat
On panel—6½ *in.* by 5½ *in.*

25. 4

REMBRANDT.

50 THE RAT-KILLER
8¼ *in.* by 6½ *in.*

10. 10

P. P. RUBENS.

51 THE FLIGHT OF LOT
On panel—18½ *in.* by 24½ *in.*

25. 4

RUBENS.

52 HEAD OF JUDAS ISCARIOT
11½ *in.* by 9 *in.*

17. 17.

D. TENIERS.

18 . 18—

53　A Toper
　　　　On panel—11¾ in. by 9 in.

F. DE WETTE.

3. 13. 6

54　Casting out the Evil Spirit
　　　　On panel—18½ in. by 31 in.

J. DE WIT.

17. 17.

55　Boys Sporting—*grisaille—a pair*　　　　2
　　　　10 *in.* by 25 *in.*

J. DE WIT.

29. 8.

56　Cupids—*grisaille—a pair*　　　　2
　　　　12½ *in.* by 9 *in.*

ITALIAN SCHOOL.

7. 17. 6

57　The Holy Family, with a female Saint
　　　　On panel—18 in. by 14 in.

F. BAROCCI.

10. 10.

58　The Holy Family, with the Infant Saint John
　　　　29½ *in.* by 24 *in.*

BOTTICELLI.

27. 6

59　La Belle Simonetta
　　　　On panel—24 in. by 19½ in.

CANALETTO.

60 A View on the Grand Canal, Venice

8. 8- — 20 *in.* by 29 *in.*

DOMENICHINO.

61 Saint Cecilia

4 · 4. Oval—25 *in.* by 17½ *in.*

GAUDENZIO FERRARI.

62 A Lunette

4 4. 2—— Half figure of the Saviour in the act of blessing ; an
angel in attitude of adoration on either side
On panel, semicircular—34 *in.* by 83 *in.*
Exhibited at Burlington House, 1907

GIOTTO SCHOOL.

63 The Madonna and Child Enthroned, with Saint John and

2 3. 2—— a Saint ; The Crucifixion in a lunette above
On panel—29½ *in.* by 17 *in.*

FILIPPO LIPPI SCHOOL.

64 The Virgin Adoring the Infant Saviour

4 4. 2. —— On panel—29½ *in.* by 14½ *in.*

LUCA LONGHI.

65 The Madonna and Child, with Saint Elizabeth and Saint

/ 15. / 0 John
42½ *in.* by 34½ *in.*

LORENZO LOTTO.

66 The Entombment

3 /. / 0. — On panel—6 *in.* by 8 *in.*

B. LUINI.

67 Saint Catherine

44.44. 2. Three-quarter partially draped figure of the Saint, looking up and clasping her hands to her breast; in front of her is a broken wheel

On panel—27½ in. by 20½ in.

Exhibited at Burlington House, 1907

LUINI.

68 The Infant Christ and Saint John

10. 10. —— *On panel—18 in. by 20 in.*

MORONI.

69 Portrait of a Gentleman, in dark dress with white collar

31. 10. —— 23 in. by 19 in.

RAFFAELLE.

70 The Infant Saint John in the Desert

68. 5. —— *On panel—44 in. by 33 in.*

S. ROSA.

71 Jason and the Dragon

52. 10. —— 29½ in. by 25 in.

G. B. TIEPOLO.

72 The Martyrdom of Saint Sebastian

21. —— 25½ in. by 17 in.

VERONESE.

73 Head of a Child, in rich dress

7. 7. —— *On panel—12 in. by 10¼ in.*

L. DA VINCI.

74 The Infant Christ and Saint John, with a lamb

94. 10. —— *On panel—18½ in. by 14 in.*

FRENCH SCHOOL.

BOUCHER SCHOOL.

75 BLIND-MAN'S BUFF
3 3. / 2 ——*On panel*—15 *in.* by 12 *in.*

CHAMPAGNE.

76 PORTRAIT OF CARDINAL MAZARIN, in red robe and cap
9 . 9. ___27½ *in.* by 22½ *in.*

J. E. LIOTARD.

77 VOLTAIRE NARRATING A FABLE
/ 8 . / 8. ——*On panel*—12 *in.* by 8 *in.*

MIGNARD.

78 PORTRAIT OF CHARLES EDWARD (the Young Chevalier), in red
5 2 . / 0. coat
27½ *in.* by 22½ *in.*

F. LE MOYNE.

79 CLASSICAL FIGURES, in a landscape
9 . 9. ——15 *in.* by 17½ *in.*

H. RIGAUD.

80 PORTRAIT OF JAMES, DUKE OF CORNWALL (THE OLD PRE-
5 0. 8. TENDER), in scarlet coat and breast-plate. In an oval
29 *in.* by 23½ *in.*

The following are Sold by Order of the Trustees of
WALTER PLEYDELL BOUVERIE, Esq.,
deceased, late of Lavington Manor, Wilts.

.DRAWINGS.

D. GARDNER.

81 PORTRAIT OF LADY FAWKENER, in black dress and
white lace cap, seated opposite to her daughter, the Hon.
Mrs. Edward Bouverie, who is in white dress, with a blue
cloak; with her grandchild, Miss Bouverie, afterwards
Countess of Rosslyn, playing between them
Pastel and gouache—22 in. by 25½ in.

/ 3 / 2 . 10 .

D. GARDNER.

82 PORTRAITS OF THE THREE CHILDREN OF THE
HON. EDWARD BOUVERIE
The son Edward, in red and blue dress, standing by a
pedestal, resting his head on the shoulder of his sister
Fanny; the elder daughter, afterwards Mrs. Maxwell, in
white dress, is kneeling on the ground playing with a dog
Pastel and gouache—22 in. by 25½ in.

5 25.

D. GARDNER.

83 PORTRAIT OF MRS. CASTLE, mother of the Hon. Edward
Bouverie of Delapré, in white and red dress, standing,
resting her left hand on a table—*pastel and gouache*
Oval—19½ in. by 15½ in.

4 8. 6

DIFFERENT PROPERTIES.

DRAWINGS.

J. DOWNMAN, A.R.A.

84 PORTRAIT OF MRS. RAWLINSON, of Ancoats Hall, Manchester,
_____in green dress with white fichu, and large straw hat with
ribands

Oval—7½ *in.* by 6¼ *in.*

2/0.

J. DOWNMAN, A.R.A., 1783.

85 PORTRAIT OF KATHERINE, DAUGHTER OF BENJAMIN HUBBLE,
Esq., of West Malling, Kent, in white dress and head-dress,
with powered hair

Oval—7 *in.* by 6¼ *in.*

3 /. / 0.

F. COTES, R.A.

86 PORTRAIT OF A LADY, in yellow and white dress; and
_____ PORTRAIT OF A LADY, in blue dress—*pastels—a pair* 2.
23½ *in.* by 17½ *in.*

2 /.

J. RUSSELL, R.A.

87 PORTRAIT OF WILLIAM WILBERFORCE, ESQ.,
Philanthropist, and parliamentary leader of the cause of
abolition of slavery

In blue coat with brass buttons, white vest and stock,
powdered hair

Signed, and dated 1801
Pastel—23 *in.* by 17 *in.*

/ / 0 . 5

J. RUSSELL, R.A.

63.

88 PORTRAIT OF MRS. WILBERFORCE (*née* Barbara
Spooner), wife of the above
In white muslin dress and muslin cap
Signed, and dated 1801
Pastel—23 *in.* by 17 *in.*

J. RUSSELL, R.A.

3 36.

89 PORTRAIT OF MRS. SARAH BELL (daughter of Samuel Syden-
ham, Esq., of Minehead) in blue dress, with white fichu,
and yellow sash, powdered hair
Signed, and dated 1795
Pastel—23½ *in.* by 17½ *in.*
Exhibited at the Grosvenor Gallery, 1889

PICTURES.

A. CANALETTO.

3 3. 12.

90 VIEWS IN ROME—*a pair* 2
10¼ *in.* by 13¾ *in.*

SIR J. REYNOLDS, P.R.A.

16. 16

91 PORTRAIT OF RICHARD BURKE, son of Edmund Burke, in
brown coat, with white stock
29½ *in.* by 24 *in.*

SIR W. BEECHEY, R.A.

1·36. 10.

92 PORTRAIT OF AN OFFICER, in scarlet coat, white vest and
black cocked hat
41 *in.* by 29½ *in.*

LUCAS DE HEERE.

93 PORTRAIT OF RALPH LUMLEY, in black dress and cap, holding his gloves

On panel—36½ in. by 26½ in.

5⁻2. / 0.

EARLY ENGLISH.

94 PORTRAITS OF A LADY, HER DAUGHTER, AND THREE SONS— *a set of five in one frame*

Ovals—11 in. by 9 in. each

94. / 0.

T. J. DE LOUTHERBOURG, R.A., 1767.

95 A HERDSMAN, with cattle, goat, sheep and donkey, in a hilly landscape

50 in. by 76 in.

5⁻7. / 5⁻.

B. VAN DE HELST.

96 PORTRAIT OF A LADY, in black dress, with blue sash and bow, lace collar and cap

On panel—27 in. by 21 in.

23. 2.

A. W. DEVIS.

97 PORTRAIT OF ISAAC OSBORNE, in brown coat and buff breeches, holding his hat and stick

29 in. by 24 in.

44. 2.

TINTORETTO.

98 PORTRAIT OF AN ADMIRAL, in armour, holding a baton

46 in. by 37½ in.

5⁻2. / 0.

SIR P. LELY.

99 PORTRAIT OF THE DUKE OF MARLBOROUGH, in breast-plate and red coat, flowing wig

49 in. by 40 in.

23. 2.

P. WOUVERMAN.

100 A LANDSCAPE, with a horseman, and peasants seated by a road

On panel—9½ in. by 10¼ in.

14 . 14,

P. DA CORTONA.

101 CHRIST AND THE WOMAN OF SAMARIA

50 *in.* by 44 *in.*

10 . 10.

REV. W. PETERS, R.A.

102 AN ANGEL CARRYING THE SPIRIT OF A CHILD

66 *in.* by 50 *in.*

Engraved by F. Bartolozzi

110 . 5

REMBRANDT.

103 PORTRAIT OF A YOUNG MAN, in brown dress and red cap

On panel—25 in. by 20 in.

50 . 8

G. TERBURG.

104 A CAVALIER, A LADY AND A PAGE

A lady in white satin dress, seated, drinking a glass of wine ; a cavalier, a page and a dog stand near her ; landscape background

27 *in.* by 22 *in.*

See description in Smith's " Catalogue Raisonné," No. 31

105.

WATTEAU.

105 LA FÊTE VENETIENNE

16 *in.* by 13½ *in.*

50 . 8 -

F. CLOUET.

106 PORTRAIT OF QUEEN MARY TUDOR, in black dress with white sleeves, and white head-dress

On panel—13 in. by 9½ in.

47 . 5

N. LANCRET.

107 LE PETIT CHIEN QUI SECOUÉ DE L'ARGENT ET DES
PIERRERIES; and an engraving, by De Larmessin 2
18½ in. by 21½ in.

44. 2-

P. LONGHI.

108 A CABARET, with masquerade figures; the Piazza of St.
Mark's in the background
On panel—18 in. by 36½ in.

25.4.

SIR W. BEECHEY, R.A.

109 PORTRAIT OF A LADY, in yellow dress and head-dress, black
lace shawl
28½ in. by 24 in.

10 10

BRONZINO.

110 HEAD OF A LADY, with red dress and white lace collar
18½ in. by 14 in.
From the Collection of A. Barker, Esq., 1879

10.10.

G. ROMNEY.

111 PORTRAIT OF MAJOR-GENERAL SIR ARCHIBALD
CAMPBELL, K.C.B., M.P., in scarlet uniform, holding
his hat and stick in his hand
60 in. by 47½ in.

189.

EARLY ENGLISH.

112 PORTRAIT OF MRS. DUNCAN CAMPBELL, in white dress, as
" Hebe "
40½ in. by 31½ in.

31. 10

G. MORLAND.

113 A VIEW NEAR A SEA-PORT, with a horseman, fisherfolk
and dog on a road; a village on a hill to the left; and a
pier, with boats on the right
Signed, and dated 1795
24½ *in.* by 29½ *in.*

42. ——

EARLY ENGLISH.

114 PORTRAIT OF A LADY, in white dress, with blue sash
29 *in.* by 24 *in.*

7. 7. ——

SIR W. BEECHEY, R.A.

115 PORTRAIT OF A LADY, in white dress, with blue sash
29 *in.* by 24 *in.*

10. 10. ——

QUENTIN MATSYS.

116 SAINT JEROME, in red robe, seated in an apartment at a table,
on which are a book, a skull, and other articles
On panel—37½ *in.* by 30 *in.*

6 3. ——

J. OCHTERVELT.

117 AN INTERIOR, with a cavalier, seated, talking to a lady, a page
standing at an open door
28 *in.* by 25½ *in.*

131. 5⁻ ——

SIR A. VAN DYCK.

118 THE DESCENT FROM THE CROSS
——25 *in.* by 18 *in.*

12. 12.

G. TERBURG.

119 TWO CAVALIERS SMOKING
—— *On panel*—12½ *in.* by 10 *in.*

50. 8.

J. OPIE, R.A.

120 PORTRAIT OF A YOUTH, in yellow dress, holding a sketch-book
> 30 *in.* by 25 *in.*

/3 . 2 . 6

BERNARDINO LUINI.

121 SAINT ANNE, in red, blue and green dress, and white head-dress, holding a book in her left hand; the right hand raised
> *On panel*—24 *in.* by 13½ *in.*
> *Part of an altar-piece, executed by order of the Torriani di Mendrisio Family*
> *From the Collection of Count Passalacqua, of Milan*
> *Exhibited at the Exhibition of Early Italian Art, New Gallery, 1893–4*
> *From the Collection of J. Ruston, Esq., 1898, when it was described as Saint Catherine*

2/0. —

N. MAES.

122 PORTRAIT OF A PRINCESS OF ORANGE, in red and brown dress, standing in a landscape
> 29½ *in.* by 24½ *in.*

78. /5.

REMBRANDT.

123 PORTRAIT OF A RABBI, in red coat with fur, wearing a medallion
> *On panel*—21 *in.* by 17½ *in.*

23. 2. —

SIR T. LAWRENCE, P.R.A.

124 PORTRAIT OF MRS. SARAH TRIMMER, AUTHORESS
> In brown dress, and high white mob cap
> 30 *in.* by 25 *in.*
> *The Artist's palette-knife sold with the picture*

/4/. /5

J. DUCK.

125 An Interior, with a musical party of a lady and three
gentlemen round a table
On panel—18 in. by 26½ in.
Sold for the benefit of the funds of the London Hospital

A. SOLARIO.

126 Portrait of the Artist, in dark dress and cap
On panel—21½ in. by 17 in.

EARLY ENGLISH.

127 A Girl, in White Dress, holding a pitcher and goblet
29½ in. by 24½ in.

D. TENIERS.

128 The Interior of a Kitchen, with eight peasants smoking
and drinking, and a woman entering at the door
On panel—14 in. by 20 in.

D. TENIERS.

129 A Peasant Playing a Fiddle, and a woman holding a
jug
On panel—7½ in. by 6 in.

REMBRANDT.

130 Head of a Man, with dark cap
21 in. by 18½ in.

EARLY ENGLISH SCHOOL,

131 Portrait of a Lady, in brown dress, seated; her daughter,
in white dress, at her side
50 in. by 40 in.

THE PROPERTY OF A GENTLEMAN.

SIR T. LAWRENCE, P.R.A.

132 PORTRAIT OF A LADY, in white dress with pink scarf,
seated by a table ; red curtain background
35½ in. by 27½ in.

29. 8-

The following are from the Collection of
J. E. FORDHAM, Esq., of Melbourn Bury.

J. VAN HUYSUM.

133 FLOWERS AND BIRD'S NEST
Flowers in an embossed vase ; on the slab on which
the vase stands, is a bird's nest with blue eggs
Signed
On panel—31 in. by 23 in.
Exhibited at Burlington House, 1878

220. 10-

J. CROME.

134 A WOODY LANDSCAPE, with a winding sandy road ; a pool
of water in the foreground
On panel—14 in. by 11½ in.
Exhibited at Burlington House, 1878

215. 5.

J. CROME.

135 A WOODY RIVER SCENE, with a peasant and three cows
— 14 in. by 17½ in.

22. 1.

THE PROPERTY OF A GENTLEMAN.

G. MORLAND.

136 BLIND-MAN'S BUFF

// 5 5. ——— 27½ *in.* by 35½ *in.*

Engraved by *W. Ward*

The following are Sold by Order of the Executors
of BROWNLOW POULTER, Esq., deceased,
late of 15 Western Parade, Southsea.

G. ROMNEY.

137 PORTRAIT OF MRS. DOROTHEA MORLEY (*née*
Jarvis, of Doddington Hall, Lincoln), wife of James

2 8 8 7. / 0 Morley, Esq.

In white frilled dress with red sash ; her hands clasped,
resting upon her lap : her hair done high, with curls falling
upon her shoulders

29 *in.* by 24 *in.*

G. ROMNEY.

138 PORTRAIT OF JAMES MORLEY, Esq., Paymaster-

3 /5. ——— General of India

In brown coat with white stock, powdered hair

29 *in.* by 24 *in.*

G. ROMNEY.

139 PORTRAIT OF MRS. ANNE POULTER (*née* Bannister)
wife of Edmund Poulter, Esq.

/5 75. ——— In pink dress, with white front, and grey scarf drawn
round her shoulder, a pink and white ribbon twisted in
her hair; foliage background. In an oval
29 *in.* by 24 *in.*

G. ROMNEY.

140 PORTRAIT OF EDMUND POULTER, Esq. (FORMERLY
EDMUND SAYER), Barrister-at-Law, afterwards Canon of

4 20. ——— Winchester
In brown coat with yellow and green vest, and white
stock; powdered hair
29½ *in.* by 24¼ *in.*

T. HUDSON.

141 PORTRAIT OF JOSEPH SAYER, ESQ.

52. 10. ——— In grey satin Van Dyck dress, with lace collar and blue
scarf
29 *in.* by 24 *in.*

T. HUDSON.

142 PORTRAIT OF MRS. LYDIA SAYER, wife of the above

6 3. ——— In blue and white Van Dyck costume, with lace collar
and a string of pearls
29 *in.* by 24 *in.*

The following are ¡Sold by Order of the Executors of A. HICHENS, Esq., deceased, late of 27 Chester Street, S.W., and "Monkshatch," Guildford.

PICTURES.

L. CRANACH.

143 PORTRAIT OF A LADY, AS "JUDITH," in green and gold dress, large red hat with feathers, and jewelled necklace; holding a sword in her right hand, and resting her left hand on the head of Holofernes
On panel—35 in. by 24 in.

68 . 5.

J. VAN GOYEN.

144 A RIVER SCENE, with village, boats and figures
On panel—21 in. by 29 in.

105.

DIRK HALS.

145 A LADY, SEATED AT A TABLE, SEWING
On panel—14½ in. by 11½ in.

105.

N. MAES.

146 PORTRAIT OF THE WIFE OF MATTHEW MOLSKONCK, in black and white dress
On|panel—16½ in. by 11½ in.

105.

SIR A. MORE.

147 PORTRAIT OF A LADY, in rich dress and cap
On panel—9¾ in. by 7½ in.

15. 15.

B. E. MURILLO.

148 A WOODY LANDSCAPE

View looking across a valley to a wooded and rocky
height, on the summit of which is a castle; in the fore-
ground a group of figures, some on horseback, and some
on foot; distant landscape on the right; cloudy sky

Exhibited at Burlington House, 1877
From the Collection of W. Graham, Esq.,1886
Exhibited at the Spanish Exhibition, New Gallery,
1895–6
Exhibited at Burlington House, 1902

262./0

G. B. TIEPOLO.

149 THE IMMACULATE CONCEPTION

Arched top—40½ in. by 22½ in.

G. B. TIEPOLO.

150 NYMPHS AND CUPIDS ON THE CLOUDS

Oval—24 in. by 18 in.

A. VAN DER VENNE.

151 PEASANTS DANCING—*a pair* 2

—16½ in. by 13½ in.

FINIS

London : Printed by WILLIAM CLOWES AND SONS, Limited,
Great Windmill Street, W., and Duke Street, Stamford Street, S.E.

CPSIA information can be obtained
at www.ICGtesting.com
Printed in the USA
BVHW041437220219
540923BV00007B/531/P

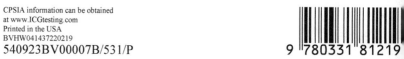